Deeply felt...

Deeply felt our pleas are rights.

Wail for loss is careless types.

Shed your tears and you may cry.

Piles on glooms are better piles.

Change in policy all must safe.

Debts repay are tyrants pays.

Shyster laws are royal court.

Tory henchman places have ports.

Near to back are darkness minds.

Brains in front are sheets for sins.

Boards and shores are men to live.

Govern most as length and width.

---------Cheung Shun Sang=Cauchy3--------

Fishes and angles...

Fishes and angle get our fames.

Games to feed are men to tame.

Tyrants forces have tame our lands.

Feel so smug is self with hands.

Bosses and chief have kinship friends.

Process comes so fine to think.

Think the Eden no pace on ways.

Earn our hays are days of hays.

---------Cheung Shun Sang=Cauchy3--------

Foods...

Feel your words are baffle gaps.

Poison fangs are adder added.

All perplexed are human seas.

Butchers meats will need a tea.

Slaughter houses are meats and foods.

Keep our life alive as loops.

Loop the hole of loops can fly.

Eat our meats and life has paths.

Some nutrition all are meats.

Boil our oils and fishes will heat.

Hunt your foes as hunt your meats.

Drinks are must and foods are needs.

--------Cheung Shun Sang=Cauchy3---------

Hearts…

Hates are rules that fill in hearts.

Bear a bitter hearts are arts.

Debts of laws are tyrant wills.

Graces will make but tyrant ills.

Lease of life is new but hard.

Laws apply are cards with marks.

Show your hands are marks with cards.

Lucky picks are dips for lucks.'

Gifts are good but gifts are sins.

Hopes and wishes at faiths are pins.

Pin our hopes and track our laws.

March or dash are coming forth.

Whitewashed facts are tyrant facts.

China lords are evil act.

Badly over lords will lord.

Hot...

Nasty nice is placeman deeds.

Lotus dreams have lotus seeds.

Henchman moves have evil guts.

Cagey words are hard are nuts.

Break your vows and not to watch.

Sins and crimes are off to wash.

Wash your games out and stop.

Fury minds are rages are hot.

Tender ways and kisses are kiss.

Thunder ways but you are miss.

Names of thunders climb our lists.

Keep our life and get our needs.

Points of orders all are hot.

Make so fun and you are mocked.

Travesty laws are travesty facts.

Joys....

Joys are heads and come to toes.

House or plaza are places I goes.

Rulers get the rules and feet.

However something smelled is sweet.

Joys are good for family trees.

Sing my poems are you and me.

Use my throats and mouth to yell.

Joys from heads to toes are well.

---------Cheung Shun Sang=Cauchy3---------

Laws concessions….

Laws concessions fight our worlds and spoil.

Aptitudes tests are heavy hands and smokes after nukes that coil. Snakes and ladders all are not for charmers.

Aquiline eagles all will make the deals and kill the snakes.

Fight may good or bad is china tyrant psychology tests.

First to think is blood that china fetched for fighting foes that is the tyrants' killed their foes.

First for bossy china over lords in terms of first thinking all is joys for pains of those who disagree to their govern long.

Laws have styles and tyrants get their moods. LOWA tests are tests for basic skills and tell us as working hard.

Me-mine-cauchy3 will test whom as who to conquer all whether good or bad for loots or places.

Not a case but not as only for placeman but all ambitious men with great desires.

More to conquers and much amuck or mad are china

Leg it….

Fury rages are foments come.

Eagles fly is hero homes.

Guns on tops are hero fly.

Catch

Life and laws..

Life cryonic needs reborn.

Laws are ways will need reformed.

Shapes to touch are faithless ways.,

Laws missing links are people rights.

Lines on faces are smiles are fates.

Truths are codes of laws but nothing fake.

Fates are causes or turns externally come.

Fates are causes are public wishes.

Fates are chances with lucks are happens ways.

All interpreted as ways are laws.

All interpreted of laws may some as tricks.

Shyster codes are legal successes.

Legal stories all are leaders throw about.

China ways as whom is to interpreted china laws.

China wills are formidable hero wills.

Congresses china is heads and chief of heresy commie pure.

Freezing laws are freezing life.

Must..

Status and trends are tyrant things.

Trends of events some may sink.

Fellow like is thick and thin.

Spies come but gone with winds.

China soldiers miffs and rages.

Ashamed as one is tyrant ages.

Huge and sudden riches have ways.

China tyrants govern our days.

Up and rise are peoples must.

Half in measures law are such.

Bully boys have dreams of prides.

Bossy bosses have evil rides.

Evils drive is soldier lines.

Who as puppeteers take the wires?

On and same has governed long.

Punitive sanctions….

Liquid flows are laws are ranks.

Liquid flows are placeman life.

Legal charms redeemed as needed. Pay you bad with wooden nickels. Nepotism gets the fruits and juices.

Banana belts are cadres' growth as tyrants' county.

Wooden nickels for little potatoes just like their strangers.

Pay you bad is bitter life.

Tyrants' wills are sharp as knife. Right to courses reset is laws. Equal laws and citizen right that go against wrong.

Tyrants ride us dry without kisses. Laws treat us bad and stir us to jails for words and our public addressing.

Strip us and exploit us by laws to ban us away from right as setting up new political party.

Who is mad and not come for cure.

Tyrants' boarder-line takes before good or bad.

Mastery bosses are bossy governs.

Tasks are winning also controls with forces.

Pure but sin ..

Who will climb a tree to catch a fish?

Fruitless ways will approach are sad.

What a cause is worlds that spoil.

Army gifts massive spoils.

Table lists are collusions making lists.

China committee charges are pure as purest commie.

Terms that contacted need to be good to public.

China terms are tyrant days.

China chronicles cover some with tyrant styles.

Must compile as obey is peoples wills

Wash their brains and servile as all.

China series numbers all are pure as purest commie.;

China pure are total just are militancy.

Who invented a story as big as chilling nerves that to be china.

Taiwan agrees to the states with antique de nerves and keeps calm.

Illusions all are powers come as high as RUPA LOKA.

ROSE...

Roses will grow and run in garden.

Clarions calls are very glories.

Smells will come is like as hitting.

Some regards are blossom history.

Blooming words will keep as flowers.

Pick our roses and not as cowards.

Must deflower some and better.

Pure as purest melt as butters.

Butter fingers drop our flowers.

Pick our roses are some with dozen.

Boots will lace and roses for placeman.

Placeman likes our roses but cagey.

---------Cheung Shun Sang=Cauchy3-------

.

Snobbish..

Cheat your bosses also defraud your subordinates.

Laws subpar are out of shapes.

Hasty and casual are all that sub able..

Extraterritorial jurisdictions need the peace and orders.

Cure a symptom of illness are nothing enough.

Cure it all are better political treats. Manage will need a heat that kind. Laws malpractice all are faults.

Stop and ban is China tyrant times. Putsch our ages are better epoch.

Some respects are human rights and easy life.

Some condemn to crime are good.

It is killing to direct their troops with evil guts.

Some that strives for fames and compliment

Share and obtain wealth and benefit one from worlds of trades by ways.

------------Cheung Shun Sang=Cauchy3--------

Sport....

Stunner sports are yells are yeses.

Jump and run their strengths must test.

Hurdles' races your legs may hurt.

Clever minds are forces are works.

Leaping over all might fly.

Winners drink our cocktails wines.

Bended your knees and such may jump.

Nothing worse is haws and hums.

--------Cheung Shun Sang=Cauchy3--------

Themes...

What a bitter themes is china worse in acts.

Forfeit farmer land and did nothing pay back for what had promised.

What a bitter theme is china tyrant talks. Press our gangs are cruel hearts. Runs amuck are all amok as mad.

.Themes are bad are come with shocks. Slots for cards are sinful datum. Wars in software are program codes. China country hired hackers mean their best.

Busses for wires may be data links. Token economies are placeman tickets. Token fears are people fears. China hegemony rattles made as fangs of very poisonous snakes.. Falconry states will train their best to fight and pick the vicious china snake eyes.

Eagle fly is hero homes.

China should not make an as wilder excuse to sin.

Win .our justices all are good for china peoples to rise their arms. Breadth of views have something differed but who got the rights.

Things...

Gusty winds are laws to blow.

Up and down our ways must go.

Tyrants get their mighty crowns.

Soldier havoc cries are loud.

Grumpy leaders fixed by deeds.

Sit at stern is mercy seats.

Peoples grunt and peoples pain.

Think about are bloody things.

Most will change but china fixed.

All subhuman all are mixed.

Out of shapes are evil makes.

Forms reformed will need the big.

Most will change but laws might fine..

Chop and change are battles times.

Come in shapes should there are laws.

Tibet..

All reflected glories some are china come against Japan.
China grasping greed as pick up Tibet for long and till now is law.
Venal official claim their own country lands.
China value china olden lands the fishing island which stand near the seas of Japan..
China says they own the fishing island.
Fishing island has change of owner countries for several times. Ok logically pick up fishing island regain their china lands.
Fishing islands back to china all as china grasping greed.
There are sin and china capture Tibet from DALA LAMA.
DALA LAMA and his precedents own and charge Tibet at the older next turns.
Now china arms are strong and all their policies may drum at the worlds but first is Japan which is this chesses and capturing cards.
One should love their country soils but fair for other

Urge...

Urge your times but treats are good.

Moral fibers are strict and firm. Bitter ways are self constraint by laws and morals. Troubles taken all may come. All that come are bubbles pops.

Ways are best and make the good. Ways are the only ways that is norms, feels, senses and laws.

Some esteem so great is noble minds. Some relished is happy family and better wealth. All reluctant all should care or forms reformed. Army cries are roars to rise.

Trust and having better faiths are good and may be strong.

Easy ways to know is how to confine some of our feels and motives wrapped around or stirred.

Signal corps or troops will know the codes.

Army havoc cries are cruel. Moral codes are troops of saints as saints of all the heroes that we are as we are. Open systems have secret data codes. Signal centers all are human brains.

Who is true as philosophy...

Put your calls in practical modes. Some may Live and some may die. Wrongs are rationalism all that random made. Random choices are always choose with life. Empiricism math is after math.

Who is true and who is false. Sartre Jean-Paul hates the America Vietnam policies.

Is he right?

Books for viewership are large.

Sartre writes many famous books.

Whether points of views are Nazi again as a gang that goes against America Vietnam policies is he.

Who had been put to labor camps?

He is Sartre Jean-Paul.

Rationalism math have groups and fields that give rise to matrix or determinants.

Rationalism axioms are all had been fixed in logical ways but not as such a case is random made. Empiricism feels are logic things as I think and all by my instincts.

Big officers..

Donald Tsang come to nabobs yachts and air plane.

Yachts and air planes belong to rich-Wong hung YU and CLOK PING SAW.

Donald Tsang comes in whole.

Half is guest and half is HONG KONG-chief., Do that half and do that whole.

Game for Donald is to do that.

Theme of Donald all are greedy half.

Build their houses with HONG KONG lands.

Hong KONG house policies must go and stop.

Half is market also half is Donald Tsang doing.

Build their houses and lands are talks are moods.

Hong KONG chief (C.E.O.) is half and half.

Fellow feels are nabob agreements.

Half a guest and half as future retired chief as riches staff will come on poses.

Money ranks is half a rank.

Straight and upright is built on sand.

China and Japan…

Maoism ways abused us by Maoism positions. Laws will drag and adding up totals. Themes are sad and themes are worse. China wounds are peoples wound. Come on well and off again as hello Japan. Forget each other for China and Japan.

China up and put and much incited to do as teacher pets or henchman working.

No good is such. Confused are laws are slaughter grades. Laws refer are best to made reviews. Mental forms reformed are moral fibers.

Pets and henchman referents are franking stamps.

China teacher pets are bases and low on means.

China confuses right and wrong. Follow clues are tyrant contour maps.

Keep prescribed by orders and moral routes.

Pick as faults are bones in eggs. Taiwan also Tibet got to set free if you mean the Japan fishing island.

China some aroused peoples' ills as wills.

China says in china ways…

Take subdues and toke your breath. China words are china hyper plugs and paradox. Calm you down by forces and mark you down with controlling ways.

Width is large as gaps and sins in hearts. Those subhuman all are ways. Measures are garbage spam is faithless royals.

Throw you by people ways and acknowledge your faults must need. Most ambush in ring is ready to hurt our china peoples. Who will plead that sins and come for penalty. More admit the crimes are something matter of facts. Who displayed our memo services with briefs of histories? China toke the tyrant ways to enforced obedience. Acting names of china teams as despotic men are china congressed men and china leaders.

Hold our best and seized our best but who taken under duress. Gods may save but we are not.

Who had been trussed up and throw to waters.

Maoism did.

China, British, America!...

China get the moods to govern strict.

Give a base to placeman as china counts.

Roles to plays are sages are men.

However china gets much to chew or swallow.

For the time being are there some rights for peoples.

As a matter of fact is some being enough.

Now their forces and world influence seem so great.

Powers grasp so hard is worse.

Are our worlds in crisis?

Final forms may be tyrants of China.

Make a shift we said yes as what to be.

Ways expend are takes are faults.

Leader poses the powers functions all by forces or nasty nice.

Who is dare and may being killed.

We

www.ingramcontent.com/pod-product-compliance
Lightning Source LLC
Chambersburg PA
CBHW061523180526
45171CB00001B/307